Desktop
YOGA

Desktop
YOGA

Bharat Thakur

wisdom
tree

Published by

Wisdom Tree
4779/23, Ansari Road
Darya Ganj, New Delhi-110002
Ph.: 23247966/67/78

Published by Shobit Arya for Wisdom Tree; *edited by* Manju Gupta; *designed* by Kamal P. Jammual; *typeset at* Marks & Strokes, New Delhi-110002 and *printed at* Print Perfect, New Delhi-110064

Contents

Introduction

The idea of writing a book on desktop yoga came to me when I visited a large corporate house. It was lunchtime and it was a funny sight to see a person bending his neck right and left, another rotating his shoulders, some others bending forward and backward while a few massaging each others' shoulders! I felt sorry for them as these are the people who form the backbone of the economy of my nation.

My research on people working in offices gave me some very strange results. For example, people who sit in front of switched-on desktops get so hypnotised that they unknowingly work longer than their required hours. Most accidents on the road happen at night because of the white line drawn on the road. The flashing headlights of an approaching vehicle illuminate it even more and people driving at night, watch the white beam of paint on the road. After driving for some hours, they get so hypnotised by it that when there is a break in that white line, they forget to turn and instead hit the divider on the road.

This is simply to explain to all those people working on computers that, unknowingly, they get hypnotised by the light coming from the

screen and, in that state of hypnosis, they tend to forget all about their body posture. So they take a comfortable position which includes a slouched back, legs spread apart and head tilted downward. If what I'm saying stands true for you computer users, then you all are likely to suffer from at least problems affecting one of the following:

- stomach;
- lumbar back;
- middle back;
- cervical area;
- shoulder.

Most computer-tables have cabinets below the desktop, leaving no space for the legs. The result is that your legs may develop veinous problems and sciatic pain along the sides. Watching the screen for hours on end, your eyesight is bound to weaken and affect your brain and blood circulation. The chances of migraine occurring are also very high. A frozen shoulder could also be a gift from your desktop. Problems like these are bound to arise even if you have the most advanced sitting arrangements — the right height for the computer, right posture for your body, correct seating, etc. These will simply decrease your problems but will not remove them.

So this book is not about the right seating arrangements nor about the correct posture for sitting at a computer, etc. It is intended for people who dare to break their habits and accept that productivity is not about working long hours but working with the right

frame of mind. Being computer professionals, your other nickname is 'creativity'. You have to create new stuff all the time and, to be truly creative, you have to get rid of that state of hypnosis you find yourself in when sitting in front of the computer screen.

So, those people who dare to pick up this book, must read it well as it affects the rest of your life. You will be free from all kinds of problems, diseases and aches and pains.

1

Man: The New Machine

Computers, computers... machines, machines... have taken over man's life today. The twenty-first century has seen a revolution with machines ruling our life. Man is now slowly and gradually functioning like a machine. Machines have no emotions. Machines have no feelings. They know no fear and have no head of their own. Machines don't have understanding. Machines are programmed to start work when a button is pressed.

Human beings ruled by machines end up becoming machines themselves. When working with human beings, if you look tired, others, even if they hate you, will tell you, "You are looking tired, my friend. Go, and rest." Machines don't say this. Machines will do the opposite and say, "Don't you see, I'm never tired? How can you leave me and go without finishing the job?"

Man made the machines in order to live happily, to live life easily, to bring speed to life. The day the wheel was invented was the day when man started moving towards machines. He started growing faster and moving faster but, in this process, he forgot what his fast movement was intended for — to make life easier!

And, with the birth of the computer, man became so impressed by speed that he forgot all other dimensions of his being, namely emotions, love and feelings.

No one is ready to pause. They pause only when they end up in the hospital. If the Information Technology (IT) revolution in the world continues at the same pace as it has done so far, the day is not far when we will see many more heads lolling in the madhouse. No doubt the IT revolution has improved life to a considerable extent for those who stay away from computers, but then there are others who work day in and day out to create software for solving millions of questions in a difficult project and this becomes their way of life. They create easy lifestyles for others by killing themselves.

I call IT professionals 'monks' who live for the sake of others. I have great respect for them as they have improved human living standards enormously but, with the compressed disc of their own lives, they have decreased their own height. Monks work to bring happiness to other people by freeing them from the basic bugs of life but IT professionals are simultaneously making people totally dependent on machines so as to make their lives more comfortable.

My father never used a computer. He loved to write letters by hand and send them by post. He never used e-mail. I once told him; "By e-mail, your letter will reach right now, within a fraction of a second."

He replied with some very beautiful lines: "Within seconds, emotions don't get any space. An emotion is to be expressed, lived, experienced and then reacted to. If you continue with your e-mails,

you will get frustrated when sharing your emotions as there is no pause or rest in between."

Well, as I said earlier, the IT world is merely a child now. But if you visualise the world about twenty years hence, you will find that the more and more you decrease the gaps in life to insert pace and speed into them, the more you will lose touch with your emotions. Towards that end, I've heard that people have started putting chips inside their bodies so that there is no need to insert cards to open the security locks of doors! This is just the beginning. Tomorrow, human beings will not be able to live because these chips may develop viruses.

So, the fight will begin. Who will have the most powerful chip? There are researchers working on programmes for inserting a chip in the brain to understand what people think. You won't be able to live if you know everything about a person who stands in front of you because you will judge him instantly. Love will disappear from the world; only intelligence will grow and man will become a robot. Are we heading towards that mechanical world? We have ruined Nature by building dams, by felling trees, by manufacturing medicines out of plants, by creating more unnatural stuff. The day is not far when man will kill God's ultimate creation — the man — by making him a robot. Heed my warning, all you super intellectual IT professionals!

There was one crazy man whose achievement in life was the atom bomb! He taught the world the art of splitting the atom and took the whole of existence to the brink of extinction. I hope you can recall

the deadly destruction caused by the bombing of Hiroshima and Nagasaki. Even now in Japan, you can see crippled people — the result of mutated genes.

It is not that our ancestors didn't know how to split the atom but they chose, instead, to carry research on the art of joining — the art that ancient India calls 'yoga', the art of union of one cell with another cell of the body, mind and soul merging with Nature to create a self-realised man — a *Buddha*.

So, go slow, work on computers to aid Nature, to understand Nature but not to change or ruin Nature. Understand, also that your intelligence is His gift. Don't try to change His wishes by making yourself a robot or changing the lives of people into robotic lives.

The Sufis say that the more one works with one's hands, the more the mind becomes still. Understand the mystics' knowledge and wisdom about making life easier, happier and liveable. Don't rush to change the world; instead, slow down the pace of growth towards the mechanical life. God knows why there is ageing and why there is death. If we were to control that also, we will see all aged human beings looking young but frustrated. Live wisely through God's given days, respect ageing and leave when asked to. Prayers will remain. There will be less crowding in the world and you will live a happy life!

The Need for a Pause

You are born, you don't know why.
You are living, you don't know why.
You are dying, you don't know why.
You have to take a pause, you have to take rest.

The aim of work is to earn a living.
The aim of living is to achieve freedom.
The day living becomes work, madness it will be!
A pause in your work will give rest to the brain,
 will give happiness to the system.

Even the sun takes rest and night takes a pause.
Stars look beautiful because they twinkle.
That's an indication of a pause taken by the star.

A pause is rest for the brain.
A pause is an inward journey.
A pause is disconnecting from the material
 world to enter the spiritual world.
A pause is the diet of the soul.

When we consistently work at a stretch, we lose out on the pauses of life. And if we make this into a habit, we will suffer from insomnia because if the brain keeps active for 12 hours at a stretch, it will not stop functioning even when we want to sleep. The West suffers from insomnia because it has forgotten the art of taking a pause. A pause can be used to disconnect the mind and get in touch with emotions of the heart.

So my book is a programme suggested for your pauses at work to help you to be more creative, more productive and get good sleep at night when you want to rest. Your anger will recede, your short temper will disappear, your body will become flexible, your eyes won't burn, you won't have any further gastric problems, your veins won't be blocked and your breathing will be easy. Yes, I advise you to take some pauses now, but you misuse these by taking a cup of coffee which contains caffeine; you smoke a cigarette and infect your lungs; you use your mind to play politics in office and ruin inter-personal relationships; you simply gossip which does no good to either you or the person you're talking about. You end up being sick, unhappy and negative. Your personality becomes negative because you use the wrong remedies to counter physical, mental and emotional weariness.

Instead of this, pick up some yogic techniques to remove the inbuilt frustrations in your mental body and improve blood circulation in your physical body. Keep the spiritual body alive and you will remain a human being, divorced from all kinds of negativities. Fear rules your system because the unknown hits the frustrated man.

Happiness comes to a relaxed, easy-going man. You need not give up work; all you need to do is take three short breaks during the day or, if you are motivated enough, take a short break every 40 minutes while at your computer and see the difference this makes.

Just three pauses in your day would gift you a smile on your face for all time to come.

3

Introduction to Desktop Yoga

The price we pay for success can be quite high. While we move from one deadline to another, from one phone call to many, from our car to our office, little do we realise how much strain we put on our bodies. In these changing times, materialistic success seems to be the only *mantra*. How much one can achieve in a short span of about 50 years of working life is all that seems to matter to the current generation. Ironically it is for this reason that several industries, for example, the pharmaceutical industry, are reaping a harvest from the increase in ill health among the working population.

Whether you are a call-centre executive or a vice-president of marketing in a company, striking a balance between work and play is a juggling act with short-term as well as long-term consequences. Like an adolescent teenager who is obsessed with his video game, little realising the adverse effects on his eyesight, posture, stress levels, hormone levels and overall sense of well-being, the executive — male or female, young or old, junior or senior — suffers from the same situation. Perhaps the stakes are higher, the responsibilities greater, the ambitions clearer, but the fact remains

13

that the body and mind of this person are undergoing tremendous strain, the results of which may or may not be visible in the present moment.

Thousands of years ago when the Indian sages developed the science of yoga, they could not have imagined that yoga practice would be most useful to a normal man living in the material world. Yoga was developed so that man could bring his body to such a level of health and fitness that it would need no mental or physical attention. This science was developed so that man could transcend his physical body and move to the subtler aspects of his mind and soul in order to discover himself. In order to do this, he had to first free himself from the various ailments that the human body had accumulated or developed. In order to sit still in meditation, he had to free himself from all kinds of back problems. He had to practice several cleansing techniques or *kriyas* in order to free himself from the toxins that he had accumulated. Just imagine yourself trying to sit still and calm your mind when you have a headache or acidity in the stomach. Man had to undergo the physical practices of yoga so that there would be no impediments to his meditation at the body or the conscious level of the mind.

The difference between you and that man is not so great as it looks. The goals might be different — the ancient man was looking for enlightenment while you look for success. But without a healthy body and a calm mind, can you really enjoy your success? One solution could be to become a renunciate, a *sanyasi* and leave the material world behind. But a simpler way would be to enjoy

worldly success without suffering from the negative effects of your work on your body and overall health. A man who lives the worldly life in a stress-free way with a beautiful and healthy body is perhaps more enlightened than those who choose to leave it all and look for peace.

There is one way to do this. If we bring awareness and alertness into our day-to-day life at work and at home, we begin the journey towards becoming a truly successful human being — one whose body, mind and soul operate in perfect harmony with each other in order to be productive, happy, successful and yet calm and relaxed through it all.

This little book entitled *Desktop Yoga* is a step in that direction. It is the art of relaxation and rejuvenation while at work. It is the art of performing your duties at an optimum level and yet not losing awareness of your inner state of well-being. Organisations throughout the world are realising that the mere presence of a man at work is not enough. His presence must be complete, must be total, must be 100 per cent but 80 per cent of the working population suffers from all kinds of work-related diseases, such as frozen shoulder, lower back pain, spondylosis, gastric problems, insomnia, migraine attacks and high stress levels which result in mood swings, volatile behaviour, depression and lethargy. A man having such problems, in real terms will only be present to a maximum of 60 per cent. He might be in office from 9 a.m. to 6 p.m. but his physical state ensures that his

concentration ranges between 10 to 60 per cent. Thus, his productivity will be almost half of what his potential is.

The art of yoga is basically simply stretching and twisting of the body. It is a simple but highly effective process to introduce focus and relaxation back into a man's system. It achieves this by activating the hormones through a stretch or twist in the body. Hormones, the quiet but powerful agents of change in the human body, can alter the emotional and chemical make-up of a man within minutes. They can provide enough energy to perform acts which in normal conditions would not be possible and at the other extreme, they can bring a man from a tense agitated state to a blissful and meditative state, all in a matter of minutes.

This book contains all the basic stretches which can be performed while sitting on your chair at your desktop. Spending a few minutes on these yogic stretches every day is equivalent to taking a vitamin pill for your body and mind. These yogic stretches will free you from your physical problems while easing out stress due to work pressures. You will feel renewed, relaxed and energised, ready to face the day with a sharp and alert mind, a healthy body and a smile on your face.

4

Basic Guidelines

In the ancient days, yoga was practiced at sunrise when the first rays of the sun emerged from the sky. It is a time when the world is quiet and the air is fresh. It is a time when oxygen level in the air is at its peak and the heat of the day has not yet come into effect. It is a time to be quiet, to be with oneself, to be alone and to be one with all life. Yoga is practiced with minimum of clothing after a cold bath on nothing more than a simple mat. Strangely, this pure and innocent science has become a multi-billion dollar industry throughout the world. Yet, the core of yoga comprising *asanas* (postures), *bandhas* (neuro-muscular locks) and *pranayama* (breath control) remains.

As a working person is usually busy till late nights, it would be virtually impossible to begin practicing yoga at 5 a.m. in the morning. This book is designed specially for those who cannot take time away from work and devote a full hour to the practice of yoga. Yet, it is important to retain some of the spirit of yoga even though a person might be enclosed in an air-conditioned 8 × 10 cubicle. Follow the guidelines given below so that your 10-15 minutes of desktop yoga can be more effective, more calming and more

rejuvenating to your entire system. Yoga is the science of entering within and being with yourself. This is not simply a geographical condition but a state of mind in which you cut yourself off from the rest of the world in order to spend time with yourself.

- Find a time during the day when you are least likely to be disturbed by others. It could perhaps be when you reach office and there are few people around.
- Not everyone may understand why you are moving strangely at your desk. Have the courage to spend a few minutes in the day doing something for yourself even if others ridicule you. With time, they will notice your condition improve and others may seek your guidance in solving the problems from which they suffer.
- One or two green plants kept in your cubicle will help calm the mind and increase the oxygen levels throughout the day and night.
- Avoid eating a heavy meal before you begin your stretches. Try to practice yoga on an empty stomach or two hours after your meal.
- Make sure you are not disturbed. Keep your mobile away and put your computer or monitor off so that disturbances are kept to a minimum. If, for some reason, you are interrupted in the middle of your practice, attend to your work and then come back to complete your stretches.
- If possible, wear loose and comfortable clothes when practicing

your stretches. If you wear a tie, remove it or loosen your collar while performing the neck stretches.

- Drink plenty of water throughout the day. Keep a bottle of water next to you and make sure that you drink at least eight bottles a day. This will keep your skin glowing and your stomach healthy.
- Eat healthy food, preferably homemade. Avoid eating heavy or fried food during lunch. Remember to fill only half your stomach with food, one-quarter with water and leaving the other quarter empty. It may require some discipline initially but it is said that in 21 days any good habit can become part of your lifestyle and seem effortless. The same applies to your yogic stretches as well.
- When stressed, remember to take deep inhalations and exhale slowly and deeply with the mouth. A mere 10 cycles of this will bring your state of being from agitated to calm and cool.
- Learn to take your problems casually as you are more likely to find solutions to problems when you are in a relaxed state rather than in a disturbed state. People respect a cool-headed person much more than a volatile personality.

5

The Neck

The human body is designed to move at all angles and every plane for its own survival. Man needs his hands, legs, back, arms, neck and head so as to perform the physical work and day-to-day activities of normal living. Every joint in the human body is built for a specific movement in a particular direction. Each joint has its own purpose and perfectly corresponds to the movement that the body needs to move.

The biggest cause of pain, dysfunction or immobility arises due to repetitive movement. Repetitive or fixed movement is a trend which has reached its peak in modern times. Only a small percentage of a certain movement is being repeated over and over again. Worse still, some work involve no movement at all.

Furthermore, the concentration and focus required is far greater in this information era and hence, so is the stress. A computer programmer faces far more stress than a machine operator mainly because of the nature of his work, which involves a high degree of concentration and mental strain. Therefore, he may do more damage

to his spine in one hour than a factory worker would in five hour: It is a lethal combination of a fixed position combined with hig concentration which leads to specific body parts literally 'freezing' c 'locking' over a period of time.

Let us start our set of yogic stretches with the neck because th neck is the primary point where stress attacks due to the man reasons given above. The brain, which is housed in the skull, i connected to the rest of the body by the neck and sends message back and forth via the spinal cord to the rest of the body.

When dealing with work requiring high concentration, a greate amount of information is being sent back and forth from the brain t the fingertips, for example, thus resulting in high stress. This hig level of stress usually tends to attack the neck area making one fee tight, stiff and uncomfortable. Tightness of neck is experienced at th lower neck as stiffness or in the higher part of the neck as locked jaw.

Ignoring this deadly but seemingly harmless disease can lead t further complications, such as spondylosis or severe neck pain o frozen jaw that can practically paralyse a man.

NECK EXERCISES

In order to relieve the stress on the neck, here are a few yogic stretches that relieve the knots and remove the blockages so that every morning your neck makes a fresh start in the day and does not accumulate the stresses which then would aggravate the problems mentioned above. Practise these once, twice or even thrice a day in order to keep your head relaxed, your neck supple and your shoulders free of burden.

Exercise 1

Position

 Sit comfortably at your desk, feet kept a comfortable distance apart.

Technique
- Place your palms on your thighs.
- Keep the back straight and slowly and gently drop the neck and head back as far as it will comfortably go.
- Hold the posture for 10-25 seconds.
- Then slowly relax the head.
- Continue to breathe normally.
- Repeat the same movement three times.

Benefits
- Loosens up and relaxes the head, neck and shoulder.
- Tones vital nerves.
- Improves blood flow to the brain.
- Helps to reduce tension and calm the mind.

Don'ts
- No jerky movements.
- Don't hold your breath.

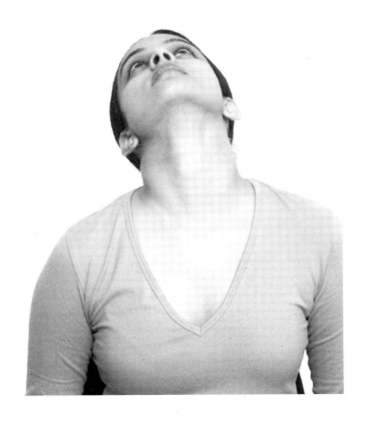

Exercise 2

Position

Sit comfortably at your desk, feet kept a comfortable distance apart.

Technique
Step A
- Place palms on your thighs. Slowly drop the head forward.
- Hold the posture for 10-25 seconds. Then slowly relax the head.

Step B
- Lower the head forward as shown in Step (A). Relax and bend the head slowly sideways.
- Hold the posture for 10-25 seconds. Then slowly relax the head.

Step C
- Now bend the head slowly down to the other side. Hold the posture for 10-25 seconds.
- Then slowly relax the head. Repeat the exercise three times.

Benefits
- Loosens up and relaxes the head, neck and shoulder.
- Tones vital nerves and improves blood flow to the brain.
- Helps to reduce tension and calm the mind.

Don'ts
- No jerky movements.
- Don't hold your breath.
- Those with cervical spondylosis should not bend the head forward.

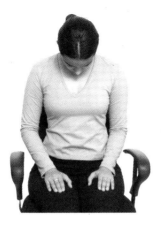

a

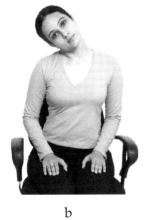

b

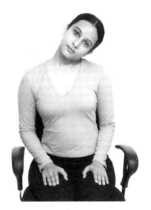

c

27

Exercise 3

Position

Sit comfortably at your desk, feet kept a comfortable distance apart.

Technique
- Slowly and gently lower the head forward and slowly rotate the neck and head clockwise.
- Reverse and rotate the neck and head anti-clockwise.
- Repeat the same movement slowly five times in each direction.

Benefits
- Loosens up and relaxes the head, neck and shoulder.
- Tones vital nerves.
- Improves blood flow to the brain.
- Helps to reduce tension and calm the mind.

Don'ts
- No jerky movements.
- Don't hold your breath.
- Those with cervical spondylosis should not bend the head forward.

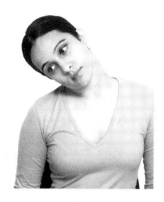

a

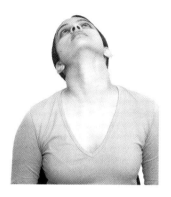

b

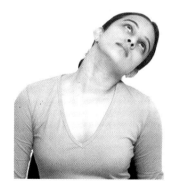

c

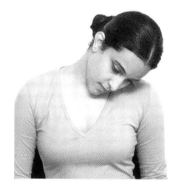

d

29

6

The Shoulders

Any man or woman with a hunched back looks ugly yet most of us gradually move towards this direction. What we do now has a direct effect on how we will look twenty years later. Look around you and look at the shoulders of your co-workers. You will find your older co-workers already suffering from poor posture and drooping, rounded shoulders. If you too face this problem, there is a way to slowly bring your physical deformity to normal but it will still take some time because years of abuse cannot be rectified in one or two months.

This modern day condition of drooping shoulders is largely due to the fixed body position during work and lack of cardio-vascular exercise. Any exercise that requires large quantities of oxygen to be inhaled, forces a man to expand his chest. In order to do this, he must pull back his shoulders to take a deep breath. Lack of exercise leads man to take shallower and shallower breaths. His weak back acquires an abnormal curve as the shoulder muscles are not strong enough to keep the shoulders straight and upright. In order to rectify the problem completely, loosening up of the shoulders is

the first step. Ideally, strengthening of the upper back combined with some form of cardiovascular exercise like jogging, swimming, cycling will eradicate this problem but right now our focus is on yogic stretches that increase blood circulation, improve lung capacity, expand the chest and loosen up the shoulders.

Since this is a desktop yoga book, nothing more can be done while sitting on a chair. Nevertheless, I hope this might mark the beginning of your journey towards a totally fit body by devoting at least 45 minutes a day to improve your health and fitness.

SHOULDER EXERCISES

Practice the following exercises once or twice a day and remember that these exercises are designed to relax and ease your body so as to prevent diseases like frozen shoulder, spondylitis, shoulder stiffness and general tightness of the upper body.

Exercise 1

Position

Sit comfortably at your desk, feet kept a comfortable distance apart.

Technique
- Place hands on your thighs, inhale and slowly raise the shoulders up towards the ears.
- Hold the posture for 10-25 seconds.
- Exhale forcefully through the nostrils as you release and drop the shoulders down.
- Repeat the same movement five times.

Benefits
- Exercises the ball-and-socket joint so that movement of the arms is possible in all directions.
- Keeps the muscles around the shoulders strong and flexible so that you do not develop a 'frozen shoulder'.

Don'ts
- Those with 'frozen shoulder' shouldn't over-stretch the shoulder muscles.

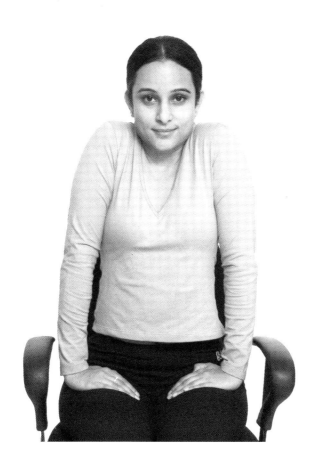

Exercise 2

Position

Sit comfortably at your desk, feet placed together or a comfortable distance apart.

Technique
- Interlock the hands behind the head.
- Supporting the neck and head, slowly push the elbows behind.
- Hold the posture for 10-25 seconds.
- Release.
- Repeat the movement five times.

Benefits
- Exercises the ball-and-socket joint so that movement of the arms is possible in all directions.
- Keeps the muscles around the shoulders strong and flexible to avoid developing a 'frozen shoulder'.

Don'ts
- Those with a 'frozen shoulder' should not over-stretch the shoulder muscles.

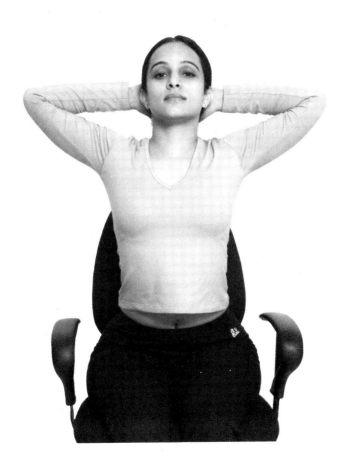

Exercise 3

Position

Sit comfortably at your desk, feet kept together or a comfortable distance apart.

Technique
- Bend one arm up behind the head.
- Twist the other arm behind as shown and interlock the fingers, pushing your upper arm back with the head.
- Hold the posture for 10-25 seconds.
- Release.
- Repeat on the other side.

Benefits
- Exercises the ball-and-socket joint so that movement of the arms is possible in all directions.
- Keeps the muscles around the shoulders strong and flexible so that a 'frozen shoulder' does not develop.

Don'ts
- Those with 'frozen shoulder' should not over-stretch the shoulder muscles.

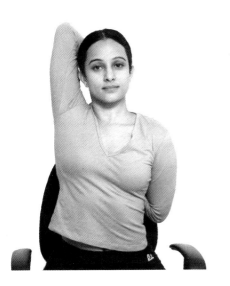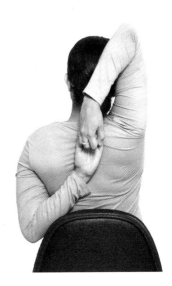

Exercise 4

Position

Sit comfortably at your desk, feet placed together or a comfortable distance apart.

Technique
- Place both hands on your shoulders.
- Slowly bring both elbows together in front.
- Slowly rotate the elbows and shoulders clockwise, raising the elbows up over the head and down again.
- Repeat the same movement anti-clockwise.
- Repeat five times in each direction.

Benefits
- Exercises the ball-and-socket joint so that movement of the arms is possible in all directions.
- Keeps the muscles around the shoulders strong and flexible so that the 'frozen shoulder' does not develop.

Don'ts
- Those with a 'frozen shoulder' should not over-stretch the shoulder muscles.

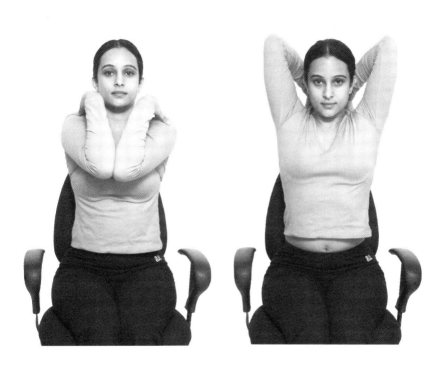

41

7

The Back

The back is the most ignored part of the body even amongst those who exercise regularly. For officegoers who sit long hours on a chair, lack of proper back exercises, stress and bad posture on the chair prove a lethal combination leading to different kinds of back pain, starting from tailbone problems to lower backache to mid - and upper-back pain. Unfortunately, pressure to perform well at work has become so high that we are willing to abuse our bodies in order to gain success in this world. Of all the body parts, the back takes 80 per cent of this abuse by being in the most vulnerable position, whether sitting or standing.

The human back is naturally shaped in the form of an S-curve. This is because the spine which forms the core of the back is itself in the shape of an 'S'. The muscles and bones around the spine are designed to protect it as well as to ensure maximum mobility in all directions — front, back, sideways as well as to twist the body when needed. It is a highly complex group of muscles and joints designed in such a way that the body can perform the same function in a

variety of different postures and choose from a variety of movements.

Any strain on any part of the back is absorbed by the surrounding muscles so that no one point becomes weak or immobile. Once again, sitting in front of a computer and working long hours in a fixed and usually uncomfortable posture, due to lack of awareness, worsens the condition of the back by subjecting it to the same pressures on the same muscles day after day. It is no wonder that almost 80 per cent people in any office suffer to some degree from some kind of backache.

Another reason for back problems is the lack of kinetic movement that is normally performed by the body. The spine which houses the spinal cord is barely utilised as the limbs too are not performing any sort of dynamic movements. Imagine your hand constantly by the side of your body — never moving up, down, left or right.

Imagine if one day, after many years, you try to move your hand to pick up a heavy object, the muscles of the hand pass through excessive strain, leading to severe muscle ache. The joints would be stiff and start hurting as they've barely been used and the arm feels numb as lack of movement causes lack of circulation. This sounds unnatural but this is probably the condition of your back as it hardly performs 10-20 per cent of the activities it is capable of doing.

BACK EXERCISES

The back exercises in the following pages are designed to stretch the muscles, improve blood circulation and gently loosen the joints of the spinal cord. Your back as a whole will feel supple, loose and relaxed and will not experience overstrain in case you happen to bend down or turn behind. These exercises will prevent your back from tightening up and slowly losing its shape as you grow older.

Exercise 1

Position

Sit comfortably at your desk, feet placed together or a comfortable distance apart.

Technique
- Interlock the palms behind the back.
- Pull down while inhaling and slowly pushing the chest out.
- Drop the neck and head back, keeping the back straight.
- Hold the posture for 10-25 seconds, breathing normally.
- Then slowly exhale as you relax the palms, the chest and raise the head. Repeat the same movement three times.

Benefits
- Exercises the ball-and-socket joint so that the movement of the arms is possible in all directions.
- Keeps the muscles flexible and no 'frozen shoulder' develops.
- With straight shoulders and upper back, the 'hunch' is removed and blood circulation in the back muscles improves.

Don'ts
- Those with a 'frozen shoulder' should not over-stretch the shoulder muscles.
- Don't hold the breath longer than stated.

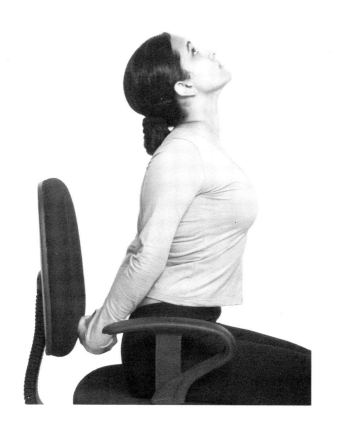

Exercise 2

Position

Sit comfortably at your desk, feet placed together or a comfortable distance apart.

Technique
- Take one arm behind and hold the chair as shown.
- With the other arm, grip the chair and slowly twist the upper waist to look behind you.
- Hold the posture for 10-25 seconds. Release and slowly return to the start position.
- Now reverse the position of the arms and twist the body in the opposite direction. Repeat the same movement five times.

Benefits
- Exercises the ball-and-socket joint so that the movement of the arms is possible in all directions.
- Keeps the muscles around the shoulders strong and flexible so that a 'frozen shoulder' does not develop.
- With shoulders and upper back straightened, the 'hunch' is removed and blood circulation in the back muscles improves.

Don'ts
- Those with a 'frozen shoulder' should not over-stretch the shoulder muscles.
- Those with back problems should do this stretch carefully.

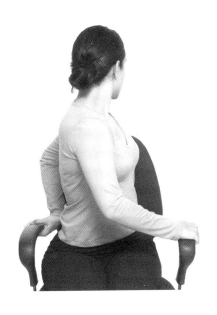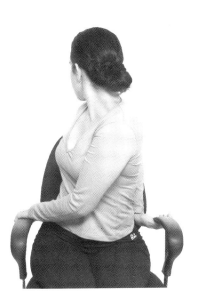

Exercise 3

Position

Sit comfortably at your desk.

Technique

- Keep one leg stretched out. Bend the other leg and place the foot on the inner thigh.
- Inhale as you slowly stretch both arms up.
- Exhale as you bend forward. Drop the head down towards the knee and both hands towards the foot.
- Hold the posture for 10-25 seconds, breathing normally.
- Release and inhale as you slowly raise your arms and come up.
- Now reverse the position of the leg and repeat the movement.
- Repeat the exercise three times.

Benefits

- Loosens the muscles so as not to develop a 'frozen shoulder'.
- Stretches the back muscles.
- Improves blood circulation in the back muscles and tones the abdominal area.

Don'ts

- Those with a 'frozen shoulder' should not over-stretch the shoulder muscles.
- Those with any back problem should take care while doing this exercise.

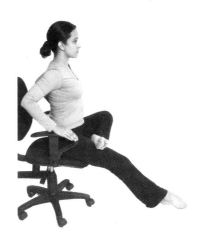

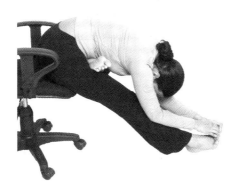

Exercise 4

Position

 Sit comfortably at your desk.

Technique

- Sitting on your chair, spread the legs apart as shown.
- Inhale as you slowly stretch both the arms up.
- Exhale as you bend forward. Place both the palms on the floor.
- Hold the posture for 10-25 seconds, breathing normally.
- Release and inhale as you slowly raise your arms and upper body.
- Repeat the same movement five times.

Benefits

- Loosens the muscles around the shoulders so that a 'frozen shoulder' does not develop.
- Stretches the back muscles.
- Improves blood circulation in the back muscles.
- Tones the abdominal area.

Don'ts

- Those with a 'frozen shoulder' should not over-stretch the shoulder muscles.
- Those with a back problem should take care while doing this.

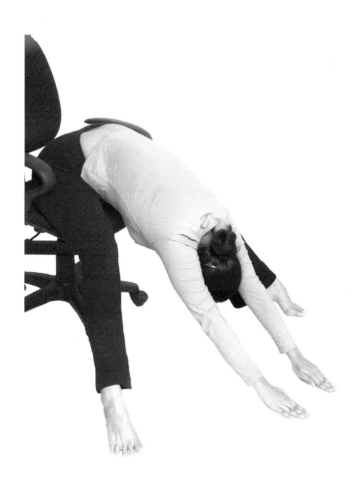

Exercise 5

Position

Sit comfortably at your desk.

Technique
- Hold the chair with one hand.
- Stretch the other arm up and bend sideways as shown.
- Hold the posture for 10-25 seconds, breathing normally.
- Release and come back to the start position.
- Repeat the exercise on the other side three times.

Benefits
- Loosens the muscles around the shoulders so as not to develop a 'frozen shoulder'.
- Stretches the sides and upper back muscles.
- Improves blood circulation in the back.
- Tones the sides.

Don'ts
- Those with a 'frozen shoulder' should not over-stretch the shoulder muscles.
- Those with a back problem should be careful while doing this.

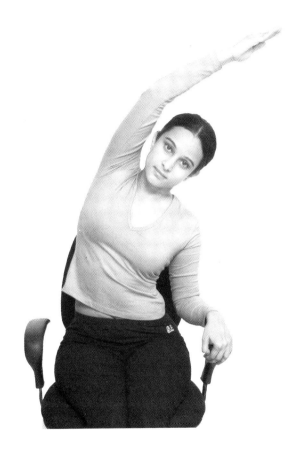

8

The Arms

The arms form one of the two extremities of the body, i.e. the legs and arms. The term 'extremity' itself indicates or implies that blood circulation tends to be low in these areas as blood has to move all the way from the heart right to the fingertips. The arms, being higher than the legs, are even more at a disadvantage since gravity can only assist the blood when it reaches the upper part of the arms. Any tightening of the fingers and the arms results in vasoconstriction or contraction of the blood vessels, leading to still poorer blood circulation in the arms.

Whether one is on the phone all day long or typing on the keyboard or reading reports, the problem that the arms face is stiffness due to the repetitive movement of the fingers or tightness of the shoulders and upper arms leading to low blood circulation.

Low blood circulation results in the joints of the fingers not being supplied well enough with blood, leading to further stiffness. Stress itself causes constriction in the vessels all round the body, leading to an overall drop in the intake of oxygen from the blood by the body.

The arms, especially the hands, are capable of extremely intricate movements. The peripheral nervous system (PNS) bypasses the brain in order to perform mechanical activities such as typing, writing, or punching in all of which delicate movements of the fingers are required.

In the olden days, intricate movements of the fingers was utilised but it was a completely mechanical activity requiring the PNS and not the central nervous system (CNS). Hence, the harmful effect was only due to the repetitive movement but not stress.

A software engineer has to multi-task several activities at one time — from the mechanical activity of his hands to using the brain to make sure that the input is correct to other parts of the brain. The brain in turn tries to get an overall picture while you attend to phone calls and people when performing the function.

The mechanical aspect remains the same but the added use of the brain results in a high level of stress leading to a tense body even while resting, or during a coffee break, or when the mechanical activity of the fingers has stopped.

The effects of stress, like rigidity, tense nerves, low blood circulation, shallow breathing still continue. So we see how the negative effects are compounded in a modern-day workplace due to the nature of the work performed.

ARM EXERCISES

The following stretches are designed to improve flexibility of the shoulder joints, increase blood circulation and develop muscular strength so that the arms can cope with daily wear and tear.

Exercise 1

Position

Sit comfortably at your desk.

Technique

- Bend one arm behind the head.
- Catch the wrist with the other hand.
- Pull down, stretching the elbow and shoulder.
- Hold the posture for 10-25 seconds, breathing normally.
- Release.
- Repeat the exercise with the other arm three times.

Benefits

- Helps to improve flexibility, strength and blood circulation in the arms.
- Stretches the muscles around the shoulders so that a 'frozen shoulder' does not develop.

Don'ts

- Those with a 'frozen shoulder' should not over-stretch the shoulder muscles.

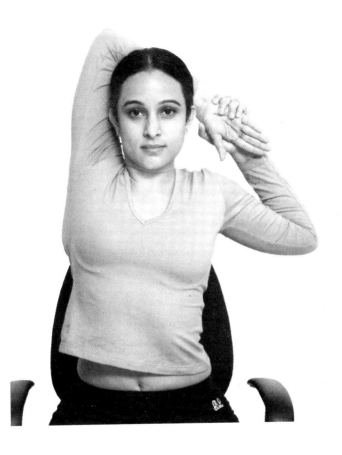

Exercise 2

Position

Sit comfortably at your desk.

Technique

- Interlock the fingers, palms turned outwards.
- Stretch both the arms forward.
- From this position, raise both the arms up, keeping the back straight.
- Hold the position for 10-25 seconds, breathing normally.
- Release.
- Repeat the movement five times.

Benefits

- Helps to improve flexibility, strength and blood circulation in the arms.
- Stretches the muscles around the shoulders so that a 'frozen shoulder' does not develop.

Don'ts

- Those with a 'frozen shoulder' should not over-stretch the shoulder muscles.

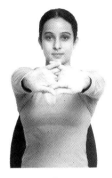
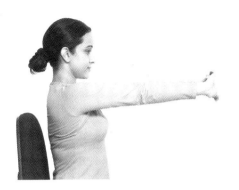

a

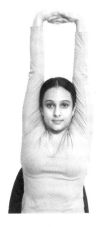

b

Exercise 3

Position

Sit comfortably at your desk.

Technique
- Take one arm behind the head.
- With the other hand, gently pull the elbow and stretch the shoulder as shown.
- Hold the position for 10-25 seconds, breathing normally.
- Release.
- Repeat the same action five times with the other arm.

Benefits
- Helps to improve flexibility, strength and blood circulation in the arms.
- Stretches the muscles around the shoulders so that a 'frozen shoulder' is not developed.

Don'ts
- Those with a 'frozen shoulder' should not over-stretch the shoulder muscles.

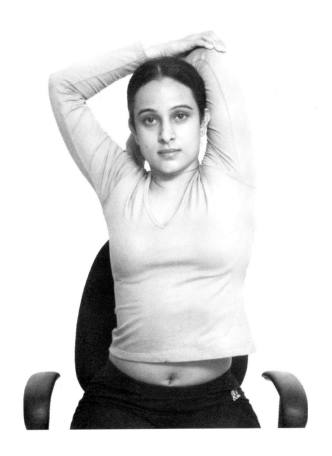

9

The Legs

The legs are the other set of extremities which suffer from similar problems as the arms — poor blood circulation and stiffness. The legs contain the longest muscles in the human body, but thanks to modern-day facilities like lifts, elevators, cars, and trolleys, we utilise our leg muscles mostly during our coffee-break or lunch-hour, though at times, even these are brought to our desk!

A simple law of the human body is that lack of usage results in deterioration. This applies to every aspect of a human being — be it his mind or body. Sitting on a chair for long hours completely cuts off blood circulation from the hip downwards. So, in addition to the exercises recommended, it is important to stand up and move around every once in a while to let the blood move to all parts of the lower body.

The legs are the strongest part of the human body as they contain the biggest and longest muscles which give the minimum of trouble as their strength combined with the basic walking most people do keeps them in an above-average condition compared to the back, the

arms or shoulders. However, low blood circulation and stiffness of the hamstrings are common problems which can result in leg aches and low energy levels as the legs are like the wheels of a car. If they are not in good condition, the entire body becomes sluggish.

Walking itself is one of the best exercises as it stimulates blood circulation right up to the toes and ankles. Ensure that whenever you can, you walk instead of taking the lift, at least once a day.

LEG EXERCISES

The following stretches will rejuvenate your legs, stretch the muscles of the upper thighs, relax the hamstrings or the back part of your thighs and loosen up the calf muscles while removing tiredness and low energy levels of your system.

Exercise 1

Position

Sit comfortably at your desk.

Technique

- Stretch both the legs out as shown.
- Inhale as you stretch both the arms up.
- Exhale as you slowly stretch forward, dropping the head on to the knees, and let the hands clasp the toes.
- Hold the posture for 10-25 seconds, breathing normally.
- Release.
- Repeat the same movement five times.

Benefits

- Helps to improve flexibility and blood circulation in the legs.
- Stretches the muscles around the shoulders so that a 'frozen shoulder' does not develop.
- Tones the abdominal area.

Don'ts

- Those with a 'frozen shoulder' should not over-stretch the shoulder muscles.
- Those with back problems should be careful.

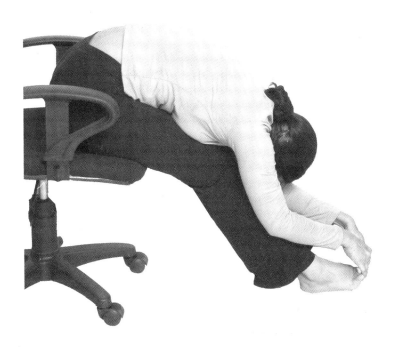

Exercise 2

Position

Sit comfortably at your desk.

Technique

- Hold the arms of the chair, keeping the back straight.
- Slowly raise one leg out. Stretch the toes forward and then inwards.
- Hold the position for 10-25 seconds, breathing normally.
- Release.
- Repeat the same action five times with the other leg.

Benefits

- Helps to keep blood circulate freely in the feet and legs.
- Helps to strengthen and keep the feet, ankles and legs flexible.

Don'ts

- Don't hold your breath.

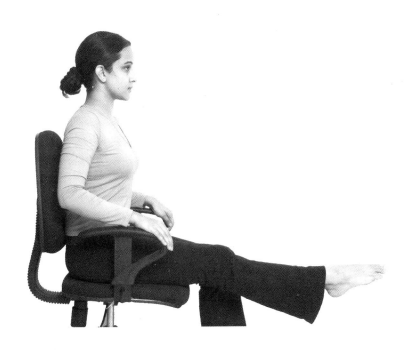

Exercise 3

Position

Sit comfortably at your desk.

Technique
- Holding the arms of the chair, raise both your legs.
- Bend the toes inwards.
- Hold the posture for 10-25 seconds.
- Release.
- Now keeping the legs in the same position, stretch the toes and feet outwards.
- Repeat the same movement five times.

Benefits
- Helps to circulate blood freely in the feet and legs.
- Helps to strengthen and keep the feet, ankles and legs flexible.

Don'ts
- Do not hold your breath.

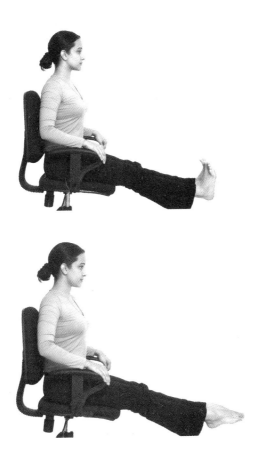

Exercise 4

Position

Sit comfortably at your desk.

Technique

- Keep the back straight and one leg on the ground. Raise the other knee up towards the chest.
- Hold the leg with both arms, gently pulling up to the chest as shown.
- Hold for 10-25 seconds.
- Release.
- Repeat the same action five times with the other leg.

Benefits

- Helps to keep blood circulating freely in the feet and legs.
- Helps to strengthen and keep the feet, ankles and legs flexible.

Don'ts

- Do not hold your breath.

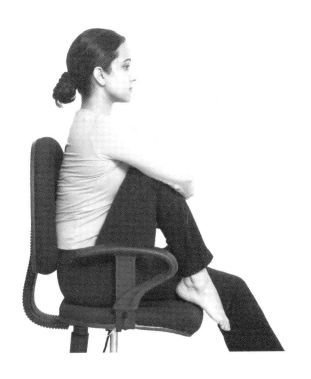

10

The Eyes

More and more people are either wearing glasses or taking to contact lenses to rectify their eye problems. The eyes are like any other muscle in the human body or rather, the lens of the eye is a muscle which needs to be exercised and kept flexible in order to perform its function properly throughout your life. Just like a muscle when it contracts, shortens and becomes fat or when it lengthens and becomes thin, the lens in your eye also contracts and lengthens depending on the distance of the object you are focusing on. Working in a closed cubicle in front of your computer all day long fixes the focal length to a specific object (the screen of a monitor). If one looks around, the most distant object nearby is only 2 metres away, while the range of your eyes can focus on an object from the tip of your nose all the way to infinity! By fixing your eye's focal length and maintaining the lens of your eye at a fixed point all day long, one slowly destroys the range of the lens and this results in various eye problems.

The following eye exercises will help to relax the eyes. In addition to these exercises, make sure you look out of the window

every once in a while and focus on very distant objects so that your eye lens is supple and fresh. Due to the high level of stress and concentration, we lose awareness of our eyes and this leads to a tensing of the muscles around the eyes. In a relaxed state, one finds that one's eyelids are slightly closed and, in a tense state, one finds that our eyelids are slightly open. This slightly open state is harmful in the long run as all the muscles of the eye are being overstrained. It is the opposite of sleep where eye muscles are completely relaxed. Thus, half-open eyes are also recommended in meditation as this keeps the eyes relaxed and yet does not allow a man to fall asleep. Erratic schedules, night shifts and lack of sleep contribute equally to making the eyes worse as one ages.

EYE EXERCISES

Practise the following exercises diligently and be aware of your eyes, keeping them relaxed at all times, even while performing work which requires a high degree of concentration.

Exercise 1

Position

Sit comfortably at your desk.

Technique
- Raise your one arm, keeping the fist clenched and thumb at eye level.
- Focus on tip of the thumb without blinking.
- Now, keeping the eyes focused on the top of the thumb and move the arm to one side as shown.
- Now move to the other side.
- Repeat three to five times.

Benefits
- Improves the focusing power of the eye muscles.
- Develops concentration.

Don'ts
- Don't move the head.

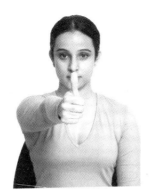

a

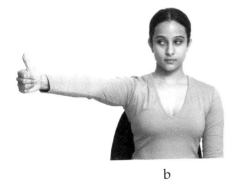

b

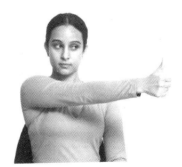

c

Exercise 2

Position

Sit comfortably at your desk, back straight, hands resting on the knees.

Technique
- Keep the head straight and body still.
- Close your eyes, relax the face and body.
- Open the eyes and look at a fixed point in front of you.
- Now, focus on the eyebrow centre.
- Hold for a few seconds.
- Close and relax the eyes.
- Repeat three times.

Benefits
- Strengthens the eye muscles.
- Releases eye tension.
- Calms the mind.
- Develops concentration.
- Retards degeneration of the pineal gland.

Don'ts
- Don't move the head.

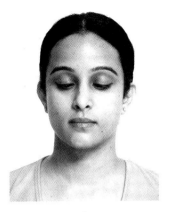

a

b

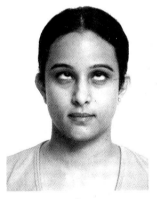

c

85

Exercise 3

Position

Sit comfortably at your desk, back straight, hands resting on your knees.

Technique
- Keep the head straight.
- Close your eyes, relax the face and body.
- Open the eyes and focus them on the tip of the nose.
- Hold for a few seconds.
- Close the eyes and relax them.
- Repeat three times.

Benefits
- Strengthens the eye muscles.
- Keeps the eyes clear and bright.
- Releases tension and calms the nerves.
- Helps improve memory.
- Helps develop good concentration and will power.

Don'ts
- Do not move the head.

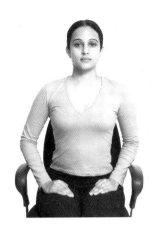

87

11

Neuro-muscular Locks
(Bandhas)

Yoga is the only science which understands and manipulates the hormone levels in our body system. Modern research has only recently begun to reveal the importance of hormones and the role they play in the functioning of the body as a whole. The yogis knew this ages ago and developed the whole system of yoga to ensure that with every posture, breath, movement and pressure, there was a change in the overall hormonal balance in the system. It is a well-known fact that a hormone called serotonin induces relaxation and a sense of well-being. Like serotonin, there are several other hormones which are known as 'hormone-releasing' hormones. These are hormones which do not directly affect the body but trigger off the release of other hormones. In simpler language, there is an entire range of hormones which can bring about changes in the emotional and mental state of a human being within a few minutes.

By practicing *bandhas* or neuro-muscular locks, we change the

internal pressure in the body and also press on the endocrine glands to make them secrete the needed hormone. Stretching the body in a posture also has this effect as it induces relaxin which, as the name suggests, is a hormone that relaxes your body. Modern science is discovering more and more new hormones which are responsible for extremely fine and subtle changes in mood and emotions. The practice of *bandhas*, in particular, affects the primary endocrine glands ensuring that moods like irritability, depression, indecisiveness and nervousness do not negatively affect our working life. A stable and centred state of mind is key in the practice of yoga.

BANDHAS

So, practicing the following three *bandhas* described can bring about a huge change in the hormonal make-up of your system. These can be practiced sitting right on your chair and will help you move towards this state.

Exercise 1

JALANDHAR BANDHA

Position

Sit on your chair, back straight, head down, hands placed on your thighs.

Technique
- Inhale deeply, raise your chest and hold your breath.
- Bend your chin slowly on the jugular notch and press hard.
- Hold your breath for 30 seconds to a minute.
- Still holding your breath, raise your chin up to the start position and exhale slowly through the nostrils. Repeat this cycle thrice.

Benefits
- By pressing the chin down on the jugular notch, the parathyroid and thyroid glands in the neck get activated and thyroxin is secreted. This hormone helps in reducing stress.
- Helps in controlling diseases of the thyroid gland.

Don'ts
- Those suffering from cervical spondylosis should not perform this *bandha* as bending the neck forward is prohibited for them.
- This *bandha* is only for people whose thyroxin levels are low. Those with high thyroxin levels should not do this.

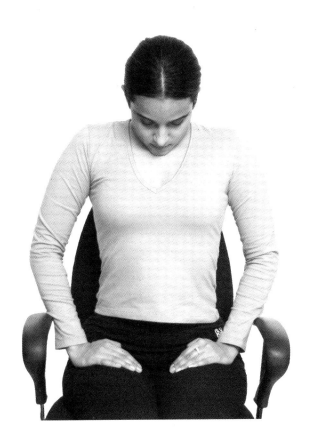

Exercise 2

UDDIYAN BANDHA

Position

Sit on your chair, back straight, hands resting on your thighs.

Technique
- Place your palms on your thighs, thumbs outward as shown.
- Lean forward and exhale deeply through the mouth and hold the breath (*wahiyah kumbhak*).
- Pull in your stomach for as long as possible. Straighten up and inhale.
- Take a few deep and long breaths to bring your breathing back to normal. Repeat the cycle two to three times.

Benefits
- Research indicates that there is a pressure change of -20 mm to -80 mm of mercury inside the abdomen during the performance of *uddiyaan bandha*. This triggers the release of gastric juices which help in the digestive process.

Don'ts
- Asthma patients should not hold their breath for too long.

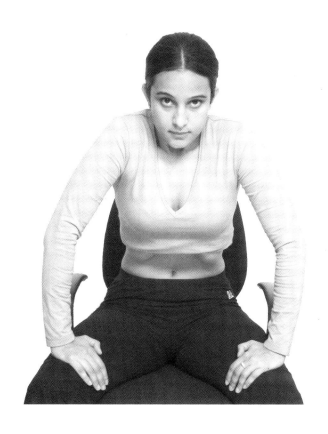

Exercise 3

MOOLABANDHA

Position

Sit on your chair, back straight, and hands placed on thighs.

Technique
- Exhale deeply through your mouth and hold your breath.
- Slowly squeeze your anal area (as you would if you tried to stop passing stool). All your lower abdominal muscles should be tightly contracted.
- Slowly release the anal area and expand your abdominal muscles.
- Inhale slowly and relax the body.
- Take a few deep long breaths to bring your breathing back to normal. Repeat this cycle three times.

Benefits
- Improves the secretion of glands situated in the lower abdominal area of the body, thus increasing vitality and sexual ability.

Don'ts
- If suffering from piles, perform this *bandha* under expert guidance.
- Women suffering from gynaecological problems should consult their doctor before performing this *bandha*.

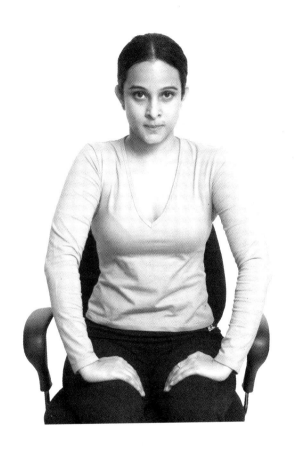

12

Breathing for Relaxation

If we look at the quality of a man's breath, we can understand his entire psychological frame of mind at that moment. The breath is one of the clearest indications of our state of mind as it can change from slow to fast and from deep to shallow, depending on our mental condition.

The ancient yogis were aware that by changing our breathing patterns, we can bring about a total change in a normally volatile state of mind. In this age when man's mind moves from object to object, from problem to problem, from entertainment to distraction, from concentration to depression, control of the breath and stabilisation of the breath can play a very important role in keeping a man relaxed and calm and yet fully alert.

When we are in an agitated state of mind, our breath rate usually tends to rise up. Not only that, the breaths are also more shallow, thus reducing the oxygen intake even while the increased breath rate is causing an additional strain on the body. Ancient yogis say that man's life can be measured by the total number of breaths taken in.

If so, then remember that you are shortening your life-span each time you move into a stressful state of mind.

Apart from the physical benefits of a slow and deep breath, correct breathing has the fastest effect on the mind. If we can change our breathing pattern by practicing some simple techniques, we can immediately bring about a relaxed state in the mind. Unlike *asanas* or postures which take time to still the mind, *pranayama* or breathing techniques directly change a stressed and contracted state of the body to a loose and relaxed state, where the mind is free from worry and tension.

A simple technique like paying attention to your breath at all times will result in a dramatic drop in your stress levels. Correct natural breathing, which is the goal of all breathing techniques or *pranayama* increases oxygen levels in the blood, slows down our breath and heart rates, relieves tension from our back and neck muscles, facilitates digestion and rejuvenates our body completely.

The goal of *pranayama* and *asanas* is to ensure that our body is in a condition such that our natural breathing improves with time. Practice the following techniques, bring awareness to your breathing and slowly try to improve the quality of your breath for the whole day and not just while practicing yoga.

BREATHING EXERCISES

It is said that a man can become enlightened simply by being aware of his breath all day long. Whether this is true or not is for you to experiment. However, I assure you that if you practice this simple technique only for 10 per cent of the day, you will soon be a transformed person.

Exercise 1

SAHAJ PRANAYAMA

Position

Sit comfortably on your chair, back straight, hands resting on your knees.

Technique
- Relax your body.
- Focus your attention on the navel region — the point of fire in the body. Inhale slowly and deeply through both your nostrils.
- Lock your chin on the jugular notch and hold your breath as long as comfortable.
- Raise your chin and slowly exhale through the mouth. Repeat three times.

Benefits
- Reduces anxiety and stress.
- Increases body temperature, burns calories and helps reduce weight.

Don'ts
- If you have cervical spondylosis, do not press the chin downwards. By keeping your chin up, practice this technique.

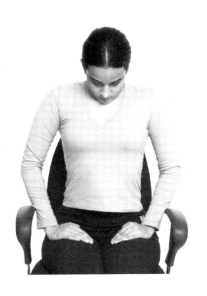 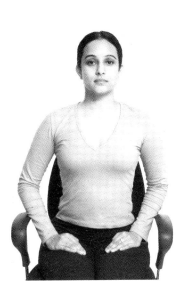

Exercise 2

KAPALBHATI

Position

Sit comfortably in your chair, back straight, hands resting on your knees.

Technique
- Relax your body and place your hands on your thighs.
- Exhale forcefully and rapidly through the nose in quick succession, pulling the stomach in towards the spine as you exhale. Inhalation will be automatic and passive between every two exhalations.
- Practise 50 exhalations at a stretch. Repeat three times.

Benefits
- Reduces anxiety, stress, while building the metabolic rate, the cardio-respiratory endurance and stamina.
- Improves digestion and excretion.
- Helps in countering sinus and migraine problems.

Don'ts
- Those suffering from high blood pressure, gynaecological problems, stomach ailments or who have undergone recent surgery, should consult their doctor before practicing this.

Exercise 3

ANULOMA VILOMA

Position

Sit comfortably in your chair, back straight, hands resting on your knees.

Technique
- Relax your body.
- Bend the forefinger and middle finger of your right hand.
- Place the thumb on the right nostril and press the ring finger on the left nostril. Breathe in through the right nostril and hold your breath.
- Place the ring finger on the left nostril and press the right nostril with the thumb. Exhale through the left nostril.
- Now inhale through the left nostril, and hold your breath.
- Reverse position of the fingers as in the third step and exhale through the right nostril. Repeat 10-12 times.

Benefits
- Reduces anxiety and calms the mind, while improving concentration.
- Body absorbs a larger quantity of oxygen and expels carbon dioxide. This refreshes and revitalises the body.

Don'ts
- Those with high blood pressure should not hold their breath.

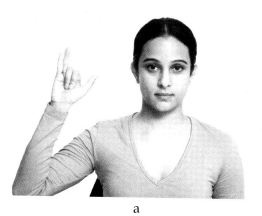

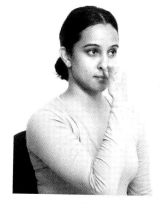

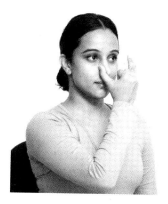

a

b

c